THE PILGRIM'S BOWL

THE
SEAGULL
LIBRARY OF
FRENCH
LITERATURE

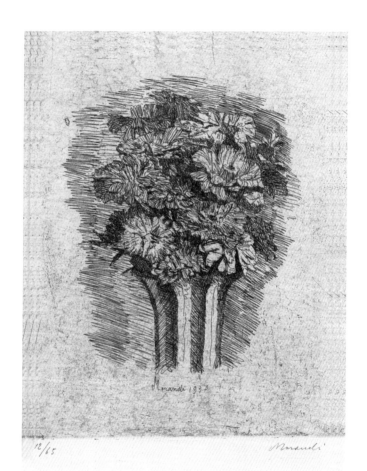

THE PILGRIM'S BOWL

(GIORGIO MORANDI)

PHILIPPE JACCOTTET

Translated by John Taylor

LONDON NEW YORK CALCUTTA

This work is published with the support of
Institut français en Inde – Embassy of France in India

swiss arts council
pro helvetia

The first edition of this publication was supported by a
grant from Pro Helvetia, Swiss Arts Council

Seagull Books, 2022

Originally published as *Le Bol du Pèlerin* by Philippe Jaccottet
© Editions La Dogana, Geneva, 2001
Images © Respective owners
English translation © John Taylor, 2015
Second printing, 2025

ISBN 978 0 8574 2 228 6

British Library Cataloguing-in-Publication Data
A catalogue record for this book is available from the
British Library

Typeset by Seagull Books, Calcutta, India.
Printed and bound by WordsWorth India, New Delhi, India

Michel Rossier
in memoriam

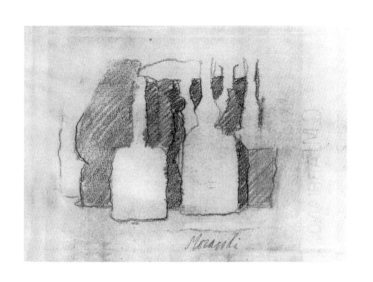

~

Whenever I face this artist's work, look at single canvases and, even more so, at certain groups of paintings—an emotion, then an astonishment in regard to that very emotion, two feelings very close to those which, in the natural world, an orchard, a meadow or a mountain slope have inspired in me and beginning with which I have more or less toiled to find words in order to make sense of the experience. Because in both the former and the latter encounters I would naively run up against an enigma—why and how do these encounters move you to this extent?

With Morandi, I am obviously spared the worry of first having to translate into words the thing that has moved me—I am not going to wear myself out using words to redo paintings that it suffices to go and see wherever they are or, failing that, as they are reproduced in books. I am not going to duplicate painted poems with written poems. Yet the other part of the

task remains—trying to understand both the reasons behind and the meaning of this emotion (that is deep and lasting enough to be worth elucidating); trying to approach the enigma.

For it is an enigma. Which engages me as much as it resists me, like that of quince flowers or meadow grass.

It is not surprising to be stirred by the view of a mountain, the ocean, a sunset, a big city; or by the imminence of a war, the nearness of a face, the death of a close friend. And therefore, consequently, by their representation in a painting, poem or narrative. But with this artist: those inevitable three or four bottles, vases, boxes and bowls—what apparent insignificance, what ludicrousness or nearly so (and all the more so when the world seems about to collapse or explode!). And how can you dare claim that such a painting speaks a more convincing language to you than most contemporary works of art?

The collector and patron of the arts, Luigi Magnani, whose Foundation houses a fine selection of Morandi's works near Parma, knew the artist well, and in his book[1] about him, he quotes the following passage, from *The Duino Elegies*, in which Rilke wonders if the time has come for poets to speak no longer of the sky or the ineffable, but rather of the earth, 'hereness', the nearby and the simple:

> *Are we perhaps here just to say: house,*
> *bridge, fountain, gate, jug, orchard, window—*
> *at most: column, tower . . . but to speak, understand me,*
> *oh to speak in such a way that things have never believed*
> *themselves to be, deep inside . . .*[2]

One could indeed think that Morandi had fulfilled through his still lifes, in his own way, what for Rilke, who lacked ingenuousness, most often remained a wish. Yet it is quickly clear that Rilke's choice of 'simple things' and 'things of here' is incomparably more varied than Morandi's, and that among these things many are not so simple—it suffices to recall the rich resonance awakened in us by words such as 'bridge', 'porch' or 'window'. Accordingly, the wish

formulated by Rilke's poetics has instead been ful-
filled by other modern painters, like Bonnard, who
admirably metamorphosed bridges, windows,
orchards and pitchers once all the gods and demi-
gods had fled or been rejected. Admittedly, we find
Morandi's still lifes almost totally deprived of this
variety, this wealth, these deep echoes. Whence the
persistence, as irritating as a challenge, of the enigma
that they put forward.

The enigma has to be approached from different
angles, as naively as possible. (For want of anything
better.)

'Monastic': this word almost inevitably crops up in
writings by people who knew Morandi or who today
seek to draw up a portrait of him. The comparison
has perhaps been overstated and runs the risk of
idealizing a man whose secretive daily life remains
little known. Nevertheless, the word keeps coming
to mind in regard to him for it is whispered into our
ears by the paintings themselves. And Morandi's life

was truly almost as immobile, silent, well ordered and even repetitive as that of a monk. However, his occupation was neither praying, nor singing, nor the study of the Holy Scriptures and the Church Fathers, nor caring for the destitute, but exclusively painting, and painting in which not only divine personages, angels and saints—with their stories—have totally disappeared but even the very faces of human creatures. (Which could make one think, wrongly, that he had no great concern for the latter.)

A life as concentrated as that of monks; as cloistered, in the cell of his studio, as theirs; as cloistered, and turning its back on the world, on the history of the world, probably in order to better open itself up, even as theirs does in regard to heaven; but such a life as his, to what end?

An 'immutably concentrated' life, as Emerson defines that of heroes—a remark that I once read as quoted by Ramuz who clearly considered this to be a model.

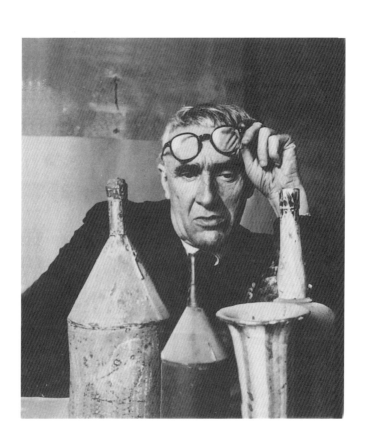

In the history of recent art, this same heroic con-
centration existed in Giacometti, but in his case with
outbursts of impatience, fury and despair, as well as
vocal outbursts, and all this during a lifetime that
remained, until the end, open to human encounters,
adventures, turmoil. In Morandi, concentration is
in its pure state.

Two artists who were very different from each other
yet both 'immutably concentrated' in a period of
truly dizzying, accelerated distraction. Standing out,
solitary and stubborn, against a background of
chaos; rising above it, each in his own way.

The photographer Herbert List's portrait of Morandi
studying a group of his familiar objects reveals such
powerful concentration in his eyes that one art critic[3]
has compared the painter's attitude to that of a 'chess
player who is considering making a move while his
mind is aware of the next moves and perhaps even
the entire match'. 'I believe,' the critic continues,
'that he devoted the same attentiveness to moving
his objects in the quiet light of his studio, on the
table draped with a sheet of white paper covered

with signs, marks and numbers corresponding to the various compositions that he never stopped changing.' A telling comparison, at least for one part of it. For the other part—Morandi obviously had no opponent sitting across from him and thus took part in no duel in which this extreme effort of concentration would have resulted only in showing himself to be better than his adversary or in seeking some reward for an entirely mental calculation.

Unless one dares to assert the grandiloquent banality that his adversary was death and that he aimed at thwarting its tricks as best he could; yet, as to Morandi's specific enigma, we would still have progressed no further.

This exclusive concentration on work that characterizes both Giacometti and Morandi can be found in their very compositions—usually a frontal view and, in the former, a focalization on the face, the model's eyes; in the latter, an increasing tendency to group, towards the centre of the canvas, objects that have long been depicted as if on a frieze.

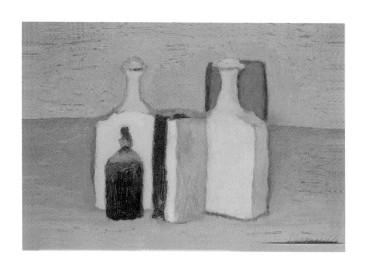

To the extent that, in both artists, everything, absolutely everything—life and work—apparently worked against distraction.

A few more lines about these two great seekers of forms and shapes: although they both followed the dictates of a sort of admirable monomania, it is important to recall that, in Giacometti, the face and personhood constitute almost the only 'subject matter' whereas they are totally absent in the other artist; moreover—let me reiterate the point—there is, in the former, a 'rage to express' that often asserts itself in commentary whereas the latter never seems to lose his calm and only rarely breaks his silence; finally, and let's add this without making any moral judgement and with simple imagery—the former willingly consorted with 'devils' while we more likely and by far imagine the latter in the company of 'angels' . . .

~

Pascal and Leopardi: the two were apparently Morandi's favourite authors, throughout his lifetime spent in his painter's cell. It is impossible that such a decisive preference cannot help us to understand him better.

Pascal and Leopardi: they are closely linked. Two short lives (they both died at the age of thirty-nine), a little less than two centuries apart; two lives burdened with illness, the ransom of extraordinarily precocious genius, and both deeply solitary. For Pascal, there was a brief 'mundane' period, followed by a violent rejection of all human attachments and a hatred of the impure body that turns one away from God; for Leopardi, forced solitude, violently desired love, yet experienced more or less only in dreams, from afar . . . Two deeply chaste lives: one by choice, the other, at least partly, or let us wager,

by fate. Thus two kinds of monks, wilfully or force-fully withdrawn into their work; two destinies to which Morandi should have felt close for this reason alone.

Pascal:

> On a vast ocean we are drifting, ever uncer-tain and bobbing about, blown this way or that. Whenever we think we have some point to which we can cling in order to strengthen ourselves, it shakes free and leaves us behind; and if we chase after it, it eludes our grasp, slips away and flees off for ever. Nothing halts for us. This is our natural state, yet the one farthest from our inclinations; we have a burning desire to find firm ground and an ultimate steady base on which to build a tower reaching to the infinite; but our whole foundation cracks, and the earth splits open into abysses.[4]

Since nature ever makes us unhappy in all of our states, our desires imagine a happy state because they add to the state in which we are the pleasures of the state in which we are not; yet if we attained those pleasures, we would be unhappy because we would have other desires in keeping with this new state.[5]

But when I thought about this more precisely and when, having located the source of all our unhappiness, I wanted to discover the reason for it, I found that there is one very effective one: the natural unhappiness of our weak, mortal state, which is so wretched that nothing can console us when we think about it precisely.[6]

And Leopardi:

Everything is evil. That is to say, everything that is, is evil; that everything exists is an evil; everything exists for an evil end; existence is an evil and directed towards evil;

the goal of the universe is evil; order and
the State, laws and the natural course of
the universe are nothing but evil and aim at
evil. There is no other good than non-being;
there is nothing good except that which is
not, things that are not things—all things
are bad.[7]

(It was necessary to let these two voices be heard,
and I will come back to them, to their status as
'voices', to their singular tone.)

This dark background for both men: a lucid, painful
awareness of the wretchedness of human beings and
the impossibility of obtaining the happiness for which
they nonetheless seem made, and of the omnipres-
ence of evil; with the aggravating factor that the
darkness seems to have gained ground from Pascal
to Leopardi, for whom an ever finer veil of illusions
no longer suffices to mask it, and from Leopardi to
us. Morandi more or less consciously worked in front
of this dark background, as did Giacometti (in whom
it is more explicitly present), even as today we live,
or survive, in front of this same background.

The ardent wager with which Pascal severs the knot of human misery ('the knot of our human state makes its twists and turns in this abyss . . .') is well known. To suppose that Morandi was able to resist the darkness with the same wilful, passionate faith seems dubious; and it would be too hasty to claim that this artist, who would perhaps have painted Madonnas and pietas in the Middle Ages, had in our time produced paintings which, although profane, offered modern equivalents of them. Even if we are told that he respected his sisters' religious devotion, even admitting that he shared it, in his own way.

'Thinking at times about diverse kinds of human agitation (. . .), I discovered that all the unhappiness of human beings comes from a single cause: they do not know how to remain at rest in a room . . .' Even if Pascal subsequently specifies that a human being without distraction is the unhappiest of all, he knows that all distraction is illusory, and that a human being who could concentrate, in silence and solitude, on only the necessary tasks is the only one who dwells

in truth. In any case, this is one of Pascal's lessons that Morandi always followed.

In regard to Pascal, Morandi once confided the following remarks to his boyhood friend Giuseppe Raimondi: 'To say that he was only a mathematician. He had faith in geometry. But do you think that this is insignificant? With mathematics, with geometry, one can explain almost everything. Almost everything.'[8] When I try to examine his paintings, I must not forget these statements, nor that 'almost everything'.

In his preface to the first major French edition[9] of Leopardi in 1964, Ungaretti writes: 'Our Leopardi: I don't know if any other writer, besides Pascal, had as much heart as he did.' Morandi was thus not the only one who had the same predilection for bringing those two names together. And the word 'heart', perhaps surprising here, can also elucidate. Notably elucidate my quick allusion to voice, to the tone of their voices.

In order to reread the same book (when it is not the Bible) every day, or almost, during one's lifetime, one must find therein more than a doctrine reduced to statements, however rigorous they might be, however strong and noble the doctrine is. What Ungaretti designates as 'heart', I construe as the ardour perceptible in the voices of these two writers, even if their voices are not identical. Their personalities are hardly lukewarm; even though they aged before their time, their souls remained spirited, adolescent, burning with a pure fire whose flares can be found again in *A Season in Hell*. (No, I am not forgetting everything that separates the three men; but their voices are related through a common tone that is inseparable from a pure fire.)

In Leopardi's poetry, the trace of fire is less visible than the chaste moonlight, that tender veil over the world, that silver sheen on all things against the background of night.

Morandi's awareness of human distress and the possible ruin of everything was equally acute, and it is possible to imagine the same extremism behind the prodigious calm of his painting (without which he would not have carried it so far).

I contemplated the serene sky,
the golden streets and the orchards,
the sea in the distance, and over there the mountains . . .[10]

Things that are distinct, all more or less remote and tranquil, in a space that is clear, well lit—as is visible in Tuscan painting, and as can be found again in at least one phase of Morandi's painting.

In the admirable unfinished sketch, *Memories of Childhood and Adolescence*[11], this fragment: '. . . and ultimately a voice: *oh, it's starting to rain*, it was a light little spring rain . . . and everyone went back inside, and the noise of doors and locks could be heard . . .' Like the other notes of this text, which might be called musical notes—notes expressing at once clarity and distance—the rare times when Leopardi experienced a remission enabling him to compose more of them, to slowly work out a canto, it was as if he were weaving together memories, dreams, desires and thoughts; forms, colours, echoes and scents; things nearby and

far away, clear or dark, but never near enough nor clear enough for the violence of his desire. Afterwards, Leopardi must have thought that illusion had vanquished him on those too-rare occasions; whereas at all other times, when he let only his mind speak, asserting that 'everything is evil' and lamenting that he had been born, he had no doubts that he had condensed his ultimate truth into a few words.

As for myself, I am still insane or naive enough to believe that a note like the one I have just quoted, whether it stands alone or is integrated and transformed into the framework of a poem, is closer to this ultimate truth—about the world, about us— than any statement, be it affirmative or negative and no matter how persuasive it is in its non-complexity.

And it is not impossible that Morandi, by keeping company with this poet, sought to be borne up by an intuition of this kind for his own art.

~

The time has come to approach these paintings that have made me unfaithful to a vow more than once confessed, professed—not to write about art. Facing them, one can imagine Morandi soliloquizing in the following way (or so we surmise, even knowing that he would never have spoken in these terms): 'Others have celebrated the wealth, the variety, the glamour of the world, and have done so by using a complex orchestration of colours and forms; this was not in my nature and is perhaps out of place today. But if one wanted to obtain the same results, by using a more limited style and means that were infinitely more impoverished, then a proportionately greater concentration would be needed. I have turned my back on the world (and given up leading what is called a life, more or less). I have locked myself up in a sort of cell with a few objects, most of which are banal and do not even recall, as do those chosen by Chardin, "humble life with easy, tedious chores";

but which will remain objects, without ever mutating into pure forms as they do with abstract painters. When I am with them again in the studio, a great silence dwells within me and around them; it is if I were rereading "The Infinite", where Leopardi "compares"—and one could say, contrasts—the "superhuman silences" imagined beyond the hedgerow to the voice of the wind blowing through the foliage; acknowledging that he finds some gentleness in getting lost in thought about infinite space (and thus composing a lyrical variation on Pascal's sentence, whose every word—every note—can be found in the poem: "The eternal silence of these infinite spaces terrifies me").

'In silence, which is necessary and beneficial to me, indeed also hides a threat; in order to counter it in the very depths of silence, I have nonetheless found, I think, something amid all the deprivation I desired.

'Of course, this is not new. Ever since the first lines ventured on cave walls, everyone who has drawn and painted has done the same thing, consciously or unconsciously—counter the threat of emptiness with frail signs, with a rustling of wind in the leaves. But with time, lavish festive colours seem to have become

deceitful, like the graceful harmonies that were made possible only through the illusion of a universal order. Ever since then, some believe they can find a kind of truth in derision or in the furious destruction of this festiveness, of those radiant forms; but derision only hastens the ruin. Others, by a strange leap backwards across Renaissances and Golden Ages, imagine that they can produce a new kind of magic by mimicking the archaic in all its forms. The path I followed is more discreet, more secretive . . .'

One thing is certain—on this path, the past is neither rejected nor imitated; nor is there the slightest borrowing of anything exotic whatsoever in time or space.

Something else: without a doubt, Morandi's mastery of artistic means, although discreetly concealed, is no less than extra-ordinary. I am incompetent in this field and will not venture further into it; and, admittedly, most technical analyses explain little. Yet in front of a group of Morandi's paintings I have

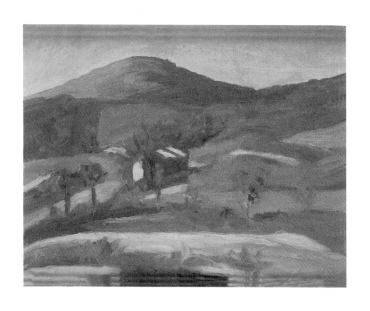

momentarily thought of Bach's mastery, at the art of variation that he displays in his greatest works: *The Musical Offering*, the *Goldberg Variations*, *The Art of the Fugue*. (And let me also toss out the name of Webern, the most densely concentrated of all composers, whose music Morandi's art perhaps also recalls . . .) In other words, a kind of mathematics that results from long subtle calculations of relations, intervals and accumulations; but calculations that no machine, no matter how complex the invention, will ever be able to perform because sensibility constantly intervenes; and in a way that seemingly becomes all the more intense and expressive, in Morandi, as his sensibility denudes itself and concentrates even more. This is where the 'almost' of his praise of Pascal can be found: 'With mathematics, with geometry, one can explain almost everything. Almost everything.'

Our world today: it would seem so similar to that stony sterile landscape, to that funereal landscape formed by the slopes of the 'exterminator' Mount Vesuvius in one of Leopardi's last cantos, 'Wild Broom', in which almost nothing would be left except

death—and the same sensation of funereal harshness and emptiness, provided by music this time, can be found in some of Liszt's late works—were it not for the ephemeral, yet persistent, scent of wild broom, of which the poem letting us sniff it represents an even more immaterial form.

Despite keeping his distance from events, Morandi lived, like all of us, under this threat and in this arid landscape; violence in its worst form did not spare the Grizanna countryside where he took refuge during a part of the war. He knew what was happening nearby and was threatening him and those close to him. He simply must have thought, or rather felt, that the only worthy response to it all was concentrating even more, if possible, on his work. While protecting himself more than ever from all eloquence, all posturing, and from resorting to any kind of occultism—like that found in a painter relatively close to him, Julius Bissier or, in a more brutal way, Tàpies, and to their expense, it seems to me. And while continuing to meditate, without the slightest ostentation, in front of the small group of objects that he sorts out, brings together, separates, tirelessly moving them, almost imperceptibly, yet calmly, like the chess player who was caught unawares by Herbert List's lens.

A kind of madness, when one thinks about it, when
one realizes that he worked in this way almost every
day for a lifetime. Yet Morandi is not mad in the
slightest; on the contrary, he is clear-sighted and
admirably calm; and if he persists without faltering,
this is because he must believe that these inex-
haustible, however minute, variations on three or
four themes are not made in vain, even under the
threat of 'Vesuvius'; and that a man thereby has the
right to restrict his entire life to this bizarre occupa-
tion, little matter how harshly the waves of time beat
up against his threshold. As if it were still worthwhile
giving something a try, even at the end of such a
long history, that everything was not entirely lost and
that one could do something else besides scream,
stutter out of fear or, worse, remain silent.

All these sentences, up to now, that explain nothing;
facing this art as mysterious as grass.

Once all the fables, which are still so radiant in
Leopardi ('The grasses and the flowers were alive, /
And the forests back then . . .'),[12] had faded away,

Morandi perhaps took one of the last, legitimate, possible paths. It is said that he would wait outside the church while his deeply pious sisters attended Mass. Did he perhaps feel closer to the beggar whom he sometimes met with on those front steps (or in the little garden, if the church were Santo Stefano, that admirable beehive) than to the faithful who were kneeling inside? And once he had returned to his studio, did it appear more fitting to paint a begging bowl than something else evoking religion or the Church (even if the latter were suffering)?

In this regard, having once noticed that the white bowl depicted in some still lifes made me think of Japanese poet-monks, I was happy to discover the following words, inspired by Giorgio Morandi's paintings, in a 'scene' composed by Jean-Christophe Bailly in evocation of the collections of the Mag- nani-Rocca Foundation in Parma: '. . . as if painting became a kind of tea ceremony, but for the eyes— an art of steeping the leaves of sensation in the water of detachment . . .'[13]

Permissible comparisons, if one does not dwell on them.

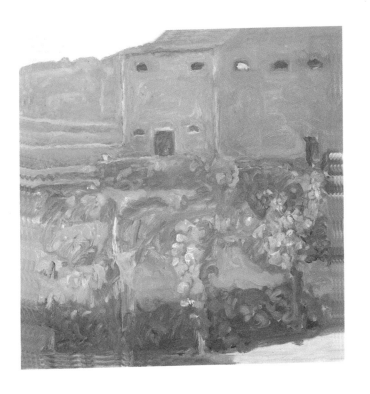

~

'Up here, there is a special hour. The ravines and the woods, the trails and the pastures turn old rust in colour, then violet, then blue: as evening comes on, the women on their front steps bend down and blow on their little portable burners, and the ringing of the bronze goatbells can be heard clearly all the way to the village. The goats show up at the doors, with eyes that seem to be ours.'

These dark and limpid lines at the end of *Casi d'altri*,[14] an admirable narrative by Silvio d'Arzo—which speak differently about this Emilian Appenine region where Morandi painted most of his landscapes.

When I first saw the landscapes he had used as models in Grizzana, one autumn not long ago, I was struck by their resemblance to those of the most remote areas of Drôme, between Nyons and Serre— here as there, an at-once mild and harsh world, an untamed world even as the painter, for whom it was a kind of native country, must also have been.

Considered carefully, Morandi's landscapes are also very strange. They are all rigorously 'without human figures'; and although most include houses, many of them have blind windows; the windows seem closed, if not empty. However, it would be an error to see them as images of a deserted world, of a 'wasteland' as in T. S. Eliot's poem. I don't think that Morandi, even unwillingly or unconsciously, used this part of his *oeuvre* to lament on the death of the countryside.

Some critics have noticed that the painter liked to let a thin layer of dust fall on the objects in his still lifes, when he did not purposely do so himself—was this like a layer of time that would protect them and make them denser? Dust often seems to veil his landscapes as well. To my mind comes the puerile image of a 'sandman' whose duty is to calm down, to put to sleep. I even think of 'Sleeping Beauty', of the *Belle au bois dormant*, as could be called the unchanging light bathing Morandi's paintings—it never sparkles or glares, never flashes or breaks through clouds, even if it is as clear as the dawn, with subtle rose and grey hues, this light is always strangely tranquil.

'Sleeping beauty' landscapes with their *lieux dormants*, their 'sleeping places'.

A veil is draped over them. One also thinks of the beautiful word 'pudeur' which will soon give the impression of having been borrowed from a dead language. But the result is also that these places, however deeply Morandi loved them in his own discreet way, often seem remote and inaccessible, like a space in which no one will ever really live.

Other comparisons, other approximations came to mind as I looked, in the Bologna museum, at a landscape from 1962, thus a late canvas[15]—houses of Campiaro seen from the front. First of all, I remembered Paul Valéry's almost too famous lines: 'Patience, patience, / Patience in the azure! / Every atom of silence / Helps ripen the fruit!'; because of the silent patience enabling works of art to ripen, because of the word 'patience' that is so beautiful and suits such landscapes so well, as it does the rest of Morandi's work, and that in turn recalls 'patina.' But Valéry speaks too elegantly, as if he were leaning against a

fireplace mantel in a salon; here, where he has nothing else to do, he should quickly be forgotten.

I will simply retain the word 'patience'. The mellow, unvarying light reigning in the painting makes one wonder whether it is morning or evening light— morning light, more likely, because of an impression of waiting—, a light that seems inside things; also like a woollen thread that would weave together all things—houses, trees, paths, and sky—for a tapestry to be hung on the walls of an impossible 'Hall of Supreme Peace'. A light that would be both internal and remote, and blend with infinite patience.

~

If I have initially examined Morandi's landscapes, this is because the presence of the natural world in them seemed likely to enhance our comprehension of them; yet their secret keeps slipping away. Will it be the same for the bouquets? (Bouquets? Really? Who would still dare to paint them today, to speak about them? And yet . . .)

Especially subtle, delicate colours are used in the bouquet paintings; colours of dawn, of things that are just beginning instead of opening out, beginning yet concentrated, dense despite their lightness. We are as far here from Impressionist shimmering as from Flemish exuberance, but neither do the bouquets speak of fragility, of ephemeral presences about to wither. It is more like—I am groping for words— dawn encompassed, perpetuated in a bud, with all that it is possible to lend of eternity to one of the

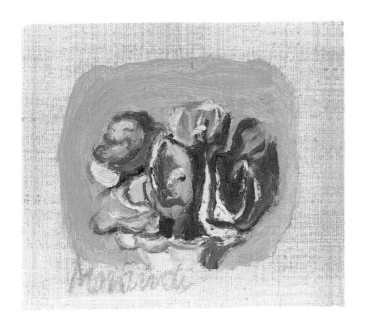

things of this world that deserves it the most. Juvenile blazons. Flowers that the *kores* of the Acropolis could have offered to Artemis if they had kept their hands.

Even if the colours appear almost used up in some of these bouquets, we are never in a world of ghosts, nor in one of suavity. Instead, some bouquets make one think of small monuments, though without anything spectral or funereal, or, perhaps, of their kinship with those Attic stelae on which the purest and the most tender aspect of life is celebrated and, strangely, a farewell looks like a dawn.

Such is the ivory to which Laure's complexion was once compared, such is the rosy hue of a cheek stirred by a first love; such is daybreak for the most beautiful days, a daybreak reoccurring every new day and greeted by a bouquet, kept inside it, welcomed into it, celebrated under the mask of flowers.

As on a branch in the month of May you see a rose . . .

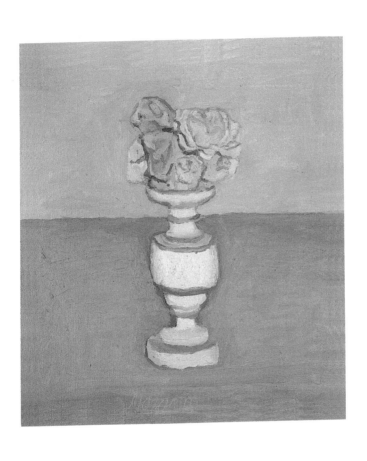

Here, one could quote one of the most justifiably famous of Ronsard's sonnets in its entirety, the one that concludes:

> *For a funeral receive my weeping and my tears,*
> *This pitcher full of milk, this basket full of flowers,*
> *So that dead or alive your body be but roses . . .*[16]

Or to come back to Leopardi, to the young girl of 'Saturday in the Village' who is coming back from the fields and 'clutching in her fingers / a spray of violets and roses,' *un mazzolin di rose et di viole,*[17] a bouquet almost as unreal as Morandi's since roses and violets do not bloom at the same time; and yet real like them in another way, in another space, in the depths.

I am aware that I am giving in here to a reverie that did not perhaps engage Morandi's mind; that many of the flowers he painted were not even real living

flowers and, that as he painted them, he was likely
thinking only of painterly problems. This matters
little—every artist worthy of the name goes beyond
painting per se and moves us only in this respect,
through a resonance in which the echoes I perceive
here can indeed play a role.

All the same—once I look again at such and such
a vase, for example, one dating from 1950,[18] across
from which the Bologna catalogue quotes Jean
Leymarie, who is not necessarily describing this
specific painting: 'Sometimes a vase emerges in its
isolated splendour, against a background of azure
or snow, and crowns itself with flowers curling
around the edges, quivering because they have per-
haps just been cut by angels, blooming, vulnerable,
in a light from the beyond.' Well said . . . But all the
same—as when I have made several detours in order
to attempt to define the enigma of a meadow, a tree
or an orchard, and then have come back to them
and have had to tell myself that I was still far short
of the target; here, once more, I must correct myself,
start all over again, those few roses in a white vase,

against a background showing two grey hues—which in the original are perhaps two ochre hues—one lighter, the other darker . . . How much simpler and firmer this is than anything I have noted down here, and Leymarie as well! There is enough to drive all commentary to despair, but 'for the greatest glory' of the *oeuvre*.

A desert rose. (I will in fact speak, a little further on, about mirages and the desert.)

A kind of Assumption—I can say no less despite my having less to say—obtained by the greatest possible deprivation, by rejecting the finery almost completely.

Ivory and sand, and ash. Shortly before sunrise.

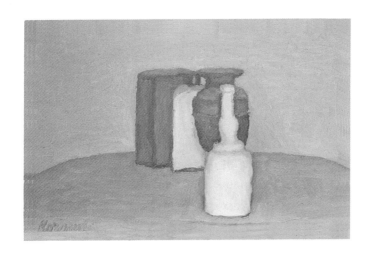

~

With his *natures mortes*, for which the English term 'still life' should be adopted once and for all—and this correction applies to Morandi's more than to any other painter's work in this genre—, the enigma increases and, accordingly, the astonishment deepens. This is because the 'subject matter' here no longer has the appeal of views of the natural world, be they landscapes or flowers, and is restricted to the few, almost insignificant objects that are characteristic of his *oeuvre*.

In the still lifes, colours[19] are sometimes especially austere and winter-like—colours of wood and snow. They make you once again pronounce the word 'patience' and think of the patience of old farmers or a monk in his frock—the same silence as beneath snow or between the whitewashed walls of a cell. The kind of patience meaning one has lived, toiled, 'withstood'—with modesty, endurance, but without revolt, indifference or despair; as if one nonetheless

expected to be enriched by this patience, to the extent of believing that the patience would allow one to be silently impregnated with the only light that matters.

Morandi long painted frieze-like juxtapositions of five, six and sometimes more objects; as the years went by, their number decreased, the composition becoming more and more concentrated and convincing, as if his first canvases were already too crowded or talked too much (to cap it off!); as if they still offered too much distraction for the mind. Now, in contrast, it is as if a traveller who had long trekked over the sand had reached the well—the 'Well of the Living One who Sees Me', as it is called in the Old Testament—and that there were no more reasons to take the slightest step further.

It can be objected that a slowly and skilfully arranged composition of simple brushstrokes, without the slightest reference to concrete reality, could produce the same sentiment of peace, the same 'consolation of the traveller'. This is not unthinkable—in Rothko,

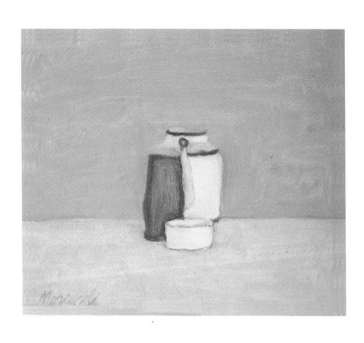

for example. Yet that this sentiment is dispensed by objects linked, even vaguely, to our daily life helps to keep us from making idealistic mental flights. As if we were reminded that a prayer said on the ground is more genuine than any other, or consoles more readily.

Among the late paintings, this teapot[20] alone, or almost alone, at the centre of the canvas—it can easily be seen that Morandi does not mix with Plato, that this is no essence or idea of a teapot, but rather that it has appeared and stands for another form of life, and with the frail trembling of life still on it.

At other times, these objects seem to be lit by a star still, or already, low on the horizon; that they are lit, I would like to say—raised back up, forgiven by this light coming from infinitely far away.

Grace said at a meal. As excessive as this seems, the thought of the pilgrims of Emmaus has come to mind—even though there is no bread nor human hands nor divine face here.

But because of the light coming from the left, I have also thought of Vermeer's paintings with their young women standing at windows, and even of the Madonna of Senigallia in Urbino (with, moreover, those blue and yellow hues that are common to these three artists). To the extent that Morandi has seemingly transferred to a vase, a bowl and a celluloid bell grouped into a sort of strange 'sacred conversation', the favour of receiving a supernatural light that would have been reserved, a few centuries earlier, for the gown of a young woman, an angel or the Mother of God. (Morandi would have been the first to reject all this. All the same, I do not want to erase it from my mind—it was not entirely without reason that I thought of it.)

The more Morandi's art progresses in terms of deprivation and concentration, the more the objects in his still lifes take on, against a background of dust, ash or sand, the appearance and the dignity of monuments.

(One night not long ago, I remembered a stopover in Ouarzazate, Morocco—rose-coloured sands and yellow sands, windy gusts blowing distant sand up into flags, and those fortress-like buildings shim- mering in the excessive light without being mirages, yet barely distinct from the ground on which they had been built—why was this brief glimpse-like vision one morning so poignant? I found myself in a part of the world I had not even passionately wished to visit, and with no personal adventure involved (for, of course, if there had been in one of those glimpsed palaces or fortresses—as in a movie!—a woman, captive or not, who I would have gone to join—to liberate!—, my emotion would have been understandable and no one would have been surprised, except for the fact that I was the hero! No, I wasn't one . . .). And what I had thus glimpsed at some distance was not even a site impregnated by the presence or the absence of gods, as Egypt or Greece had offered me on other occasions. A pure mirage, therefore? More likely, the 'illusion of the threshold',

for there began the desert, the idea of something extending boundless in front of us— and less foreign to my tastes than the ocean—and the inebriation that comes from the thought, from this foundation for the light, completely dusty with fire, and from these sands made for the bare feet of seers, while protecting the entrance—like the empty fortresses watching over certain gorges in borderline mountain valleys—is the kind of castle that is made of the same material as the sands and that our childhood dreams, nourished with books . . . Something out there, in front of us, although we would not be going further, neither that day nor later, must have risen from deep inside me, something binding me to almost all other men since the beginnings of their history—and here was something to stir me, as when one returns from exile.)

It is the colours of the sand, the mirage of objects that have become monuments in an almost empty space, and the fusion of all this which can perhaps excuse, at this point in the text, a digression even more absurd, at first glance, than my preceding ones.

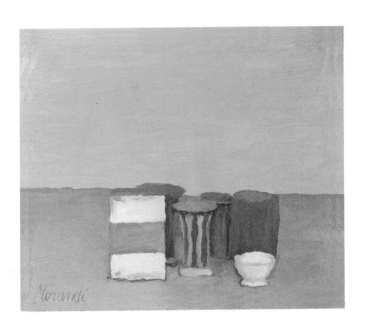

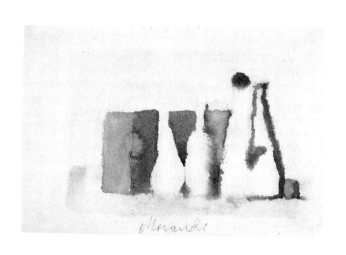

Morandi

Paintings—the still lifes from the 1960s—in which only a few objects are placed, grouped together, nearly in the centre but not quite; in which they almost blend into one another; in which they take on the appearance of monuments at once noble and poor, like standing stones; whose outer edges tremble a little without ever drifting off into frailty or blurriness.

In all the exhibit rooms where I have seen a few of these final paintings, in Marseille a few years ago and in Bologna recently, dwelt a radiant silence.

Perhaps one sees the burning candles of the final vigil there, a link between sunset and sunrise. Yet this vigil has nothing funereal about it.

It is an infinitely calm reflection of light that is coming from elsewhere and that one never wearies of following, of recalling, of awaiting. 'In queste sale antiche, / al chiaror delle nevi . . .' Morandi surely

knew by heart this miraculous fragment of 'Le Ricordanze',[21] and also knew that it does not only express, despite appearances, regrets about an illusory and irrevocably lost paradise.

~

Now that I am once again leafing through the catalogue of the watercolours shown in Florence at the Medici-Riccardi Palace, in 1991,[22] my admiration grows, from page to page, until it reaches a kind of astonishment; this toned-down art, this art of almost nothing, paradoxically stirs me to acclamation. From page to page, that is, more or less precisely, from year to year, from month to month, one seems to be climbing higher and higher towards a peak. And the first words that come to mind to qualify these watercolours will be 'nobility', 'elegance', 'altitude'. I can do nothing about this.

Because of this rising movement, of these successive levels, I have naturally thought of Dante, of the cantos of *Purgatory* and *Paradise*, which does not mean— must I add this?—that I am comparing their respective *oeuvres* and, even less, that I want to hoist Morandi up alongside Dante into a new Parnassus. That would be absurd.

But a more precise, if not more legitimate, parallel has nonetheless taken shape in my mind because of a sentence lingering there. It was written by the critic Cesare Brandi, who notes that, in Morandi's painting, things seemingly come to us from the depths of space even as memories emerge from the depths of time, and he specifies: 'Like a point far out in the sea that little by little becomes a ship . . .'[23] As a result, it is impossible not to recall that prodigious moment, in Canto II of *Purgatory*, when the angel-ferryman arrives by sea in a dazzling acceleration of the light:

> *And there as, at the approach of morning,*
> *Through the close-gathered mists Mars glows deep red,*
> *Down in the west, above the level sea,*

> *So appeared to me—may it not be the last time—*
> *A light coming over the sea so swiftly*
> *That its motion was faster than any flight;*

> *So that when I had withdrawn my gaze*
> *A little, to make enquiry of my escort,*
> *I saw it again already brighter and bigger.*

Then on each side of it appeared to me
A little blob of white; and from underneath,
Bit by bit, another blob appeared.

My master still stood there without a word,
Until the first whiteness appeared as wings:
Then he easily recognized the pilot.

He cried: 'Quickly, quickly, bend your knees:
It is the angel of God: put your hands together:
From now on you will see such officers.

See how he scorns all human implements,
So that he does not wish to have other sail,
Between such distant shores, than his own wings.

See how he has them straight against the sky,
Striking the air with his eternal wings,
Which are not ruffled as mortal hair would be.'[24]

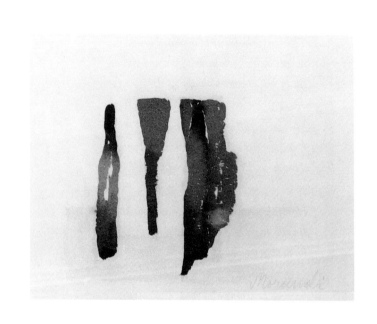

However excessive this might seem, I had noticed the first blanks or 'whitenesses' that turn out to be wings in some watercolours from 1959;[25] it can no longer be determined if they are tall white bottles or, rather, seemingly upright intervals or gaps that specifically look like a pair of stainless wings . . .

Let us accept this parallel as if it were a cloud crossing the mind in its white ingenuousness and vanishing while leaving barely a trace and an indication.

To a certain extent, moreover, there is nothing extraordinary about our exaltation, literally speaking, when reading Dante; if this exaltation were lacking, the poet would not have been up to the task.

However, no Beatrice attracts Morandi's eyes and hands, and no one can seriously seek to find in his work an angel 'beating the air with its eternal feathers'. This being said, if this impression of rising, which is undeniable when the evolution of his work is studied, is not deceptive, how can it be understood? And all the same, beginning with these almost insignificant things—the inevitable vases, jugs and bottles—doesn't one experience a sort of ascension,

even an Assumption that seems real and in fact speaks to us only because it is no longer angel wings, nor the dance and laughter of any Matilda, that announce and prepare it?

One then recalls the even more ancient ascension to which Plato invites us in *The Banquet*. Yet wouldn't this ascension to pure ideas lead instead, in art, to that paradise for geometricians such as is offered by Mondrian's final works, a space in which there is no more room for breathing—an unbreathable paradise? Even when the colours have become greatly rarefied and the shapes have almost vanished, Morandi's painting keeps on breathing—a little as if the quivering of the final word that could be pronounced by human lips were still perceptible in it?

The monument-like shapes that I saw in the last oil still lifes now become something like stelae of air.

One or two things of this world, therefore, one or two familiar things once again, not abstracted from this world so that they can be raised to the level of an Absolute that would be a synonym of death but, rather, alleviated to the right extent so that the traveller can keep them with him when taking the final step? Things that have become provisions for the journey? Raised to the only degree of transfiguration that is for them, for us, accessible today?

Try as I will—my emotion and my admiration, which are indissociable when facing this *oeuvre* and especially its final phase, its 'highest circle', would be extravagant if a kind of Assumption of things were not taking place, an Assumption culminating in their near disappearance; yet with this essential aspect, that if the things withdraw, if they vanish, first of all they are by no means reduced to evanescent entities, to sighs, to ghosts, to misty fragments—as too often happens in a certain kind of modern painting to which it is tempting, wrongly, to compare this *oeuvre*—, but rather strangely retain something monumental about them: one could venture to say, like stelae of air that a king

without a kingdom and 'without distractions' had raised at nameless borders, at the ultimate edge of the visible world; secondly, and especially, by almost fading away, by almost vanishing—the final quivering of human speech that also reminds me of the '*tremolar della marina*' of the beginning of *Purgatory*, the final rose, the final yellow, the final blue, or rather, the very first colours, those at sunrise—; it is not emptiness that they bring to light; it is not to emptiness that they surrender their positions (for otherwise we would look at them only with fright); it is not when facing emptiness that they would withdraw, vanquished or too docile but, rather, before the invading light that is going to absorb them.

Likewise, while changing the perspective—those final words, pronounced without stammering in a near murmur, that silence they barely seem to precede, is not at all the silence of death or of any end; words, instead, that seem to be the hearth of all words, or their bud, ready to blossom once again.

As if the painter had patiently opened up a path to the most appeasing light we could ever hope to glimpse.

~

'With mathematics, with geometry, one can explain almost everything.' In this 'almost' lies the very pulse of our lives, the uncertainty and the elans of the heart; which allows Morandi to be much more than a very subtle organizer of shapes. Through this 'almost' blows the breath preventing us from ending up as prisoners of numbers. This can doubtless be said, on the condition of not forgetting that numbers are also essential.

Standing back a bit: I still find myself far short of the target, after all these remarks, as when, having finished writing about a meadow, I see the real meadow again—so much simpler than anything I had been able to say, and more secretive! But it is probably better like this, and to the advantage of the meadow or to these paintings, both being little inclined to let anyone speak on their behalf . . .

Standing back still a little further: after all, nothing forces me to make these efforts. I could just as well set down my pen and spare myself disappointment. Is it momentum that keeps me going? The fear of declining due to a lack of exercise before the end? Or some less avowable reason?

But I have also come to think, over the years, that excessive scruples and self-flagellation only waste time and energy in certain circumstances; that it would be better, in such circumstances, to accept one's naivety and go forward. This is what I am doing here, taking no more detours, and speaking plainly; even if, in the final reckoning, I might seem to be quite a simpleton.

I need to go back to Leopardi's note quoted above ('and finally a voice . . .') and contrast it to the passage in his *Zibaldone*, in which he proclaims desperately, insistently, that 'all is evil'; in order to restate my intuition that the former minute note, while asserting rigorously nothing in regard to morals or philosophy, seemingly speaks more truly than any idea categorically asserting anything about our destiny. As if pure reason were indeed insufficient for approaching truth.

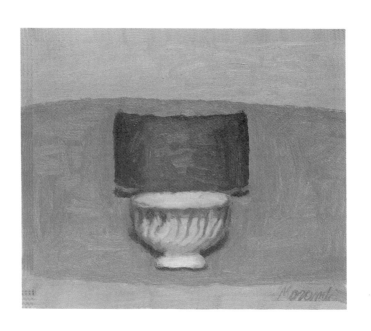

This bond between the beautiful, the good and the true, which, I am told, has been definitively severed, if it ever existed, or must quickly be severed in our minds if we persist in musing about it—why, after all, must it be re-established between the true and what is evil? Since we are indeed mortal, why must death be absolutely 'truer' than life? Why would light alone be a lure, and not darkness?

Admittedly, these sentences are a little heavy to carry on my shoulders; also a little too grandiose for my mind which is almost as narrow as they are. Yet this is where a few encounters have led me in my life, including those with Giorgio Morandi's *oeuvre*, with that light so supremely calm and so ungraspable that endless peace for the rest of us once again seems imaginable.

This almost-white bowl next to a box, a vase, a bottle—doesn't it seem better made than any other so that a pilgrim can take it along in his baggage and, at the halt, at the 'Well of the Living One who Sees Me', fill it with something that will quench his

thirst? Even, or especially, an immobile pilgrim who, if his feet no longer carry him, now travels only in his thoughts?

Notes

[The following notes are included in the original French
edition. In order to translate the quoted poems or passages,
I have gone back to the French, German and Italian
originals. All translations are mine unless otherwise indi-
cated.—Trans.]

1 Luigi Magnani, *Il mio Morandi* (Turin: Einaudi, 1982).

2 Elegy IX. 'Innig' is difficult to translate. For Rilke,
 this word designates more than a simple innerness;
 an ardour (which Roger Lewinter alone, and perhaps
 rightly, has explicitly rendered in his version). But the
 place in the line is ambiguous. I think that Rilke
 wanted to suggest that things, metamorphosed by
 poetic discourse, attain an intense innerness that
 would surprise them if they themselves became aware
 of it. Something else: 'Obstbaum' of course means
 'fruit tree'; but how could one not introduce 'verger'
 ('orchard') here when one knows how much Rilke
 regretted that this word did not exist in the German
 language? [For this English edition, I have followed
 Jaccottet for 'orchard'. —Trans.]

3 Giuliano Briganti, in a text that appeared in *La Repub-
 blica* (Rome, 11 December 1984) and that is quoted

on p. 92 of the catalogue of the Morandi Museum of Bologna.

4 Blaise Pascale, *Oeuvres* (Paris: Gallimard, Bibliothèque de la Pléaide, 1954), p. 1109.

5 Ibid., p. 1131.

6 Ibid., p. 1139.

7 Giacomo Leopardi, *Du 'Zibaldone'* (Michel Orcel trans.) (Cognac: Le Temps Qu'il Fait, 1987). [*Zibaldone*, p. 4774. —Trans.]

8 Giussepe Raimondi, *Anni con Morandi*, (Milan: Mondadori, 1970).

9 Giuseppe Ungaretti, Preface to Giacomo Leopardi, *Oeuvres* (Paris: Éditions Del Duca, 1964).

10 'À Silvia' in Giacomo Leopardi, *Poèmes et fragments* (Michel Orcel trans.) (Geneva: La Dogana, 1987), p. 72–7.

11 Ibid., p. 190ff.

12 'Au printemps, ou des fables antiques' (Georges Nicole trans.) in *Canti* (Paris: Gallimard, 1982).

13 Jean-Christophe Bailly, *Fuochi sparsi* (Parma: Teatro Stabile di Parma, 1998).

14 Silvio d'Arzo, *Maison des autres* (Bernard Simeone trans.) (Lagrasse: Verdier, 1988).

15 Lamberto Vitali, *Morandi: Catalogo generale*, 2 VOLS, (Milan: Electa, 1977), NO. 1287; see also Morandi Museum, Bologna, *Il Catalogo*, (Milan / Florence / Bologna: Charta, 1993), NO. 57.

16 Pierre de Ronsard, 'Sonnet IV' in *Le Second Livre des amours*. See Pierre de Ronsard, *Oeuvres* (Paris: Gallimard, Bibliothèque de la Pléaide, 1993), p. 254.

17 Giacomo Leopardi, *Poèmes et fragments* (Michel Orcel trans.) (Geneva: La Dogana, 1987), p. 105.

18 Vitali, *Catalogo generale*, NO. 708; see also Morandi Museum, *Il Catalogo*, NO. 33.

19 Vitali, *Catalogo generale*, NO. 1056; see also Morandi Museum, *Il Catalogo*, NO. 47.

20 Vitali, *Catalogo generale*, NO. 1318; see also Morandi Museum, *Il Catalogo*, NO. 58.

21 Leopardi, *Du 'Zibaldone'*, p. 82. [The Italian lines can be rendered: 'In these ancient halls, / brightened by snowlight.' —Trans.]

22 Museo Mediceo, Florence, *Morandi: Gli acquerelli*, exposition catalogue (Milan: Electa, 1990).

23 Cesare Brandi, 'Appunti per un ritratto di Morandi',
 Palatina (January–March 1960). Cited in the catalogue
 Morandi: *Gli acquerelli*, p. 143.

24 Dante, *Purgatoire*, Canto II (Jacqueline Risset trans.)
 (Paris: Flammarion, 1988). [English translation from
 The Divine Comedy, *Purgatorio II* (C. H. Sisson trans.)
 (Manchester: Carcanet, 1980), p. 159–60. —Trans.]

25 Cf. catalogue *Morandi*: *Gli acquerelli*, NOS 55–7.